PHOTOGRAPHING TURKEY RUN

PHOTOGRAPHING TURKEY RUN
A Guide to Nature Photography

Daniel P. Shepardson

Produced by Purdue University Libraries Scholarly Publishing Services
Distributed by Purdue University Press

Copyright 2016 by Daniel P. Shepardson.
All rights reserved.

Print ISBN: 978-1-62671-075-7
Electronic ISBN: 978-1-62671-074-0

Photographing Turkey Run: A Guide to Nature Photography is produced by Purdue University Libraries Scholarly Publishing Services and distributed by Purdue University Press. This is supplementary content for use in conjunction with Daniel P. Shepardson's *A Place Called Turkey Run: A Celebration of Indiana's Second State Park in Photographs and Words* (Purdue University Press, 2016). The book may be purchased through the publisher's website, www.press.purdue.edu.

Dedication

To my parents, Mary and Phil, who instilled in me an appreciation for all places wild. And to Susan Britsch, a good friend, colleague, and companion, who provided suggestions and edits for formatting and writing this book. Finally, to Turkey Run, for providing me the opportunity to hike, explore, and photograph nature.

About the Author

Daniel P. Shepardson is a professor of geoenvironmental and science education at Purdue University. He holds a joint appointment in the Department of Curriculum and Instruction and the Department of Earth, Atmospheric, and Planetary Sciences. Shepardson is a nationally recognized nature photographer and author. He teaches introductory environmental science and environmental education courses at Purdue. He received his PhD in science education from the University of Iowa and both his MSEd in science education and BS in wildlife science from Utah State University. Shepardson is an avid nature lover, who spends his free time hiking and photographing nature in Indiana's state parks and local nature preserves. He spends several weeks every summer in Yellowstone and Glacier National Parks.

Contents

Introduction, x

Aperture: Sharpness and Focus, 2

Shutter Speed: Capturing Movement, 4

Depth of Field: Area of Focus, 7

Light: Friend and Foe, 10

Composition: The Rule of Thirds, 12

Composition: Line and Shape, 14

Composition: Photostitching, 16

HDR: High-Dynamic Range, 18

Up Close: Extension Tubes, 20

Focal Length: Wide-Angle versus Telephoto, 22

Planning and Luck: Taking Advantage of the Situation, 24

Seeing Nature: Telling a Story, 26

Conclusion: The Power and Importance of Nature Photography, 32

INTRODUCTION

Turkey Run State Park, and the many other state parks and natural areas in Indiana, provide the nature lovers and photographers unique places to experience and photograph nature. With the advancement of digital cameras, many of us now have opportunities to photograph nature and share our experiences with others. Yet, there is a difference between taking a photograph and composing one: there is a degree of knowledge and skill to composing a captivating photograph of nature. The tips and techniques that follow are designed to provide a basic understanding about how to photograph nature and to improve the photographs you take. I followed these techniques in composing the photographs that appear in my book, *A Place Called Turkey Run*.

Photographing nature is about seeing nature in a new way. It's about seeing lines and shapes, and contexts and relationships, and it's about using light. It's also about having

and using the right equipment. To this end, I always hike with a camera pack that contains a 10–24 mm wide-angled lens, a 150–600 mm telephoto lens, neutral-density filters, and a cable release, in addition to extra batteries, cards, and lens cleaner. I hike with my Sony A77 mounted with an 18–300 mm lens, and I find this to be a good all-purpose lens. I make every effort to use a tripod to reduce camera shake, and I often use a circular polarizing filter to reduce glare and reflection, and to enhance color. All of my lenses are protected with an ultraviolet (UV) filter that also saturates colors by blocking reflected light. I switch between aperture priority and shutter priority depending on the shot, and I almost always bracket shoot, capturing three images at the same time: properly exposed, underexposed, and overexposed.

The best times of day to photograph nature are dawn and dusk, when the light is softer and warmer, and the angle of the sunlight creates shadows that add contrast to the scene. Unfortunately, we are not always able to shoot at dawn or dusk, and must learn to cope with midday light, which is harder and cooler. How we compose our shot makes a difference at any time of the day, but it is especially significant during midday light. I have also found that overcast days are the best for photographing fall colors and spring wildflowers, as the rich and vibrant colors of the leaves and

flowers and the texture of the foliage appear more vivid. Most important is practicing—getting out and shooting. With digital cameras we can shoot many images with little expense and learn from our mistakes. We have all been disappointed by our photographs, but by following and practicing these simple techniques, we can greatly enhance the quality of our images.

Daniel P. Shepardson

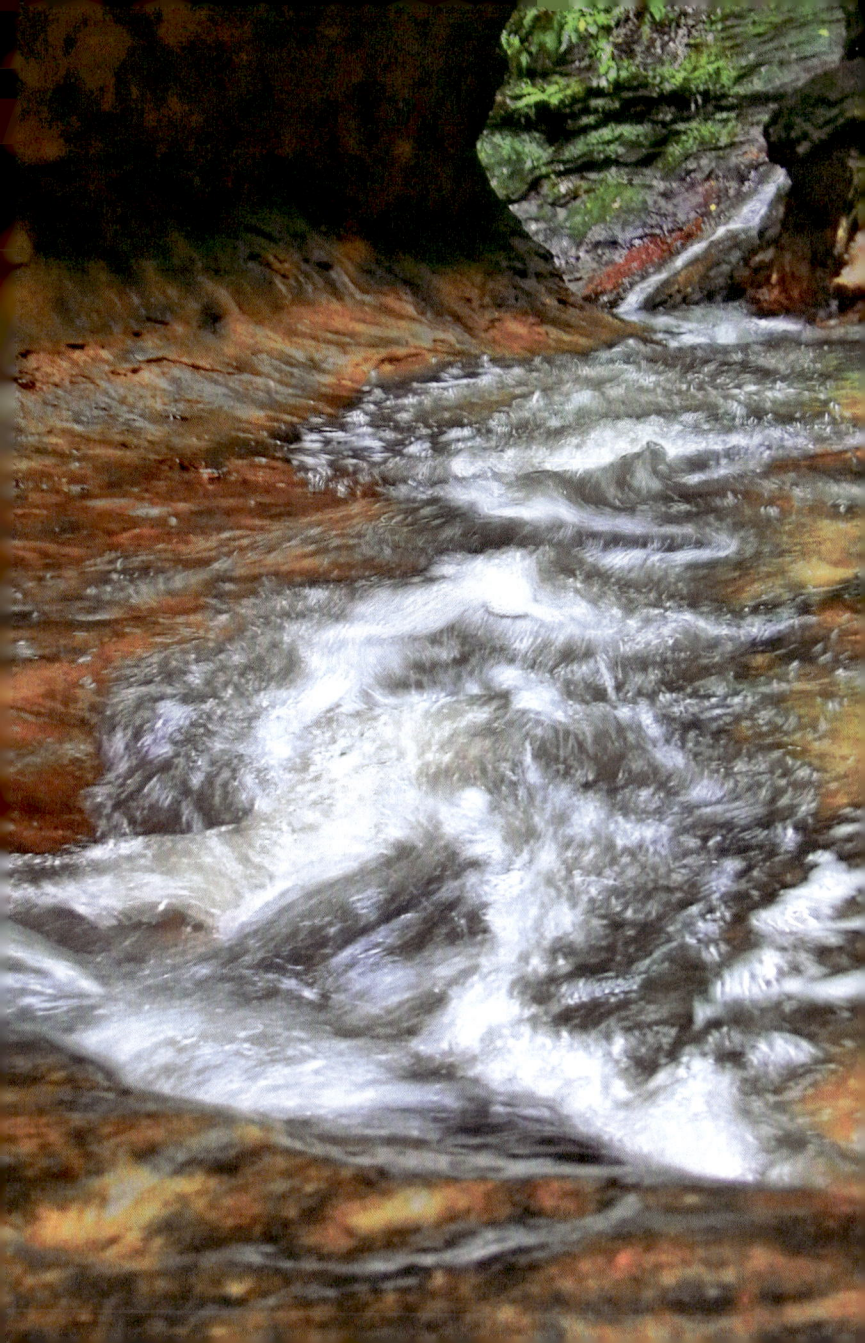

APERTURE
Sharpness and Focus

The aperture, or *f*-stop, determines the size of the lens opening, which controls the amount of light entering the camera. The larger the *f*-stop, the smaller the lens opening. The *f*-stop number is actually a fraction, which is why a larger *f*-stop means a smaller lens opening. Thus, an aperture of $f/2$ lets more light enter the camera than an aperture of $f/22$. In addition to controlling the amount of light that enters the camera, the aperture setting also determines the depth of field, or the area of the photograph that is in focus. The larger the *f*-stop (smaller opening), the greater the depth of field. The aperture setting also affects sharpness, or the degree of detail displayed in the image. In general, images are sharper when taken at aperture settings between $f/8$ and $f/16$; I often consider $f/11$ the sweet spot. Thus, if you want sharper images, you sacrifice depth of field, and vice versa. The other factors that come into play are the focal length of the lens and the distance between the camera and the subject, which will be discussed later.

I took this image after a rain event. The wet sandstone reflected the sunlight, giving the scene a green-gold glow.

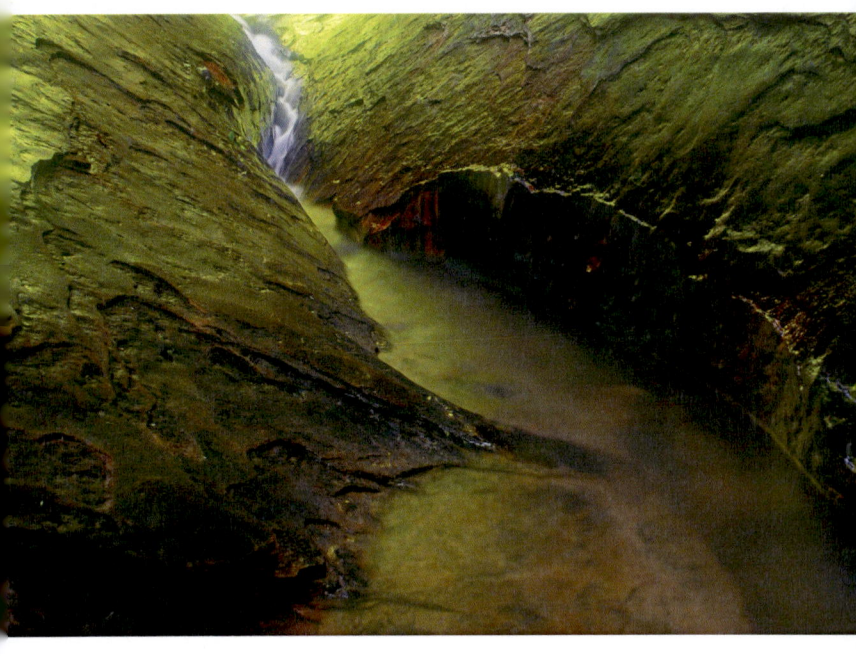

f/11, 10 sec, 30 mm

I wanted to capture the detail of the sandstone, so I set the aperture at *f*/11 for maximum sharpness and focused on the midpoint in the image. The narrower depth of field softened the background. I also used a slow shutter speed, 10 sec, which smooths the flowing water, giving the little waterfalls a glow. On your next photo hike, use a tripod and shoot the same subject using different *f*-stops. I often take photographs of the same scene at different *f*-stops to see how depth of field changes the look of the image.

SHUTTER SPEED
Capturing Movement

Shutter speed determines the length of time the shutter is open, allowing light to enter the camera. Shutter speed is important because it determines the amount of motion captured in the image. The faster the shutter speed, the less motion captured, and the more "frozen" in time and space the subject appears. Slower shutter speeds capture more movement, the trace of the subject in time and space. This of course blurs the moving object, which may be good or bad, depending on the effect you are going for. A tripod is a must when shooting at slow shutter speeds to avoid camera shake. One factor to consider when photographing flowing water is the speed and turbulence of the water. The slower the flow of water, the longer the shutter speed needed to capture its movement. Another factor to consider is the amount of available light, as this influences which aperture setting you choose. In bright light situations, there is the potential to overexpose the image at slow shutter speeds. To compensate for this, I use a circular polarizing and/or a neutral-density filter. These reduce the amount of light entering the camera, allowing you to shoot at slower shutter speeds without overexposing the image.

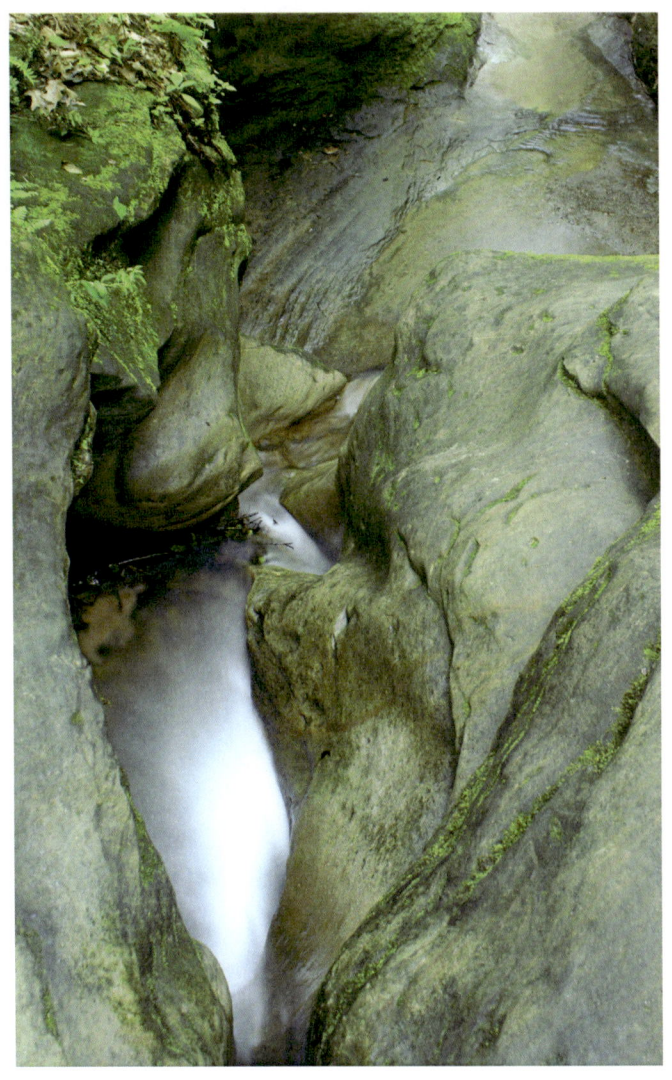

f/8, 5 sec, 20 mm

The circular polarizer also reduces reflection or surface glare. To capture the water's movement in this image, I took several shots at different shutter speeds. At 1 sec the water's movement was not visible, and at 10 sec the image was slightly overexposed. Because I used a circular polarizing filter, I was able to use an aperture setting of $f/8$ and a shutter speed of 5 sec. I have photographed grasses, leaves, flowers, and snow blowing in the wind at slow shutter speeds. On your next hike, experiment with photographing moving objects at different shutter speeds.

DEPTH OF FIELD
Area of Focus

Depth of field is the area of the photograph that is in focus. This area of focus is determined by (1) aperture or *f*-stop, (2) the focal length of the lens, and (3) the distance between the camera and the subject. As previously mentioned, the smaller the aperture, the greater the depth of field. At the same time, depth of field decreases as the focal length of the lens increases. The trade-off here is that you gain magnification but lose depth of field. For example, the previous image was taken at a focal length of 20 mm. This provided a greater depth of field, allowing the entire image to be in focus. The trillium plant image here was taken at a focal length of 200 mm. This magnified the foregrounded trillium and compressed the depth of field. The depth of field also decreases the closer you are to your subject, regardless of the focal length of the lens. Again, you are trading magnification for depth of field. To take the trillium image, I positioned myself as close to the foregrounded trillium as possible in order to compress the depth of field. The combination of the focal length of the lens and the distance from the subject allowed me to blur the background. This simplified the background and accentuated the main trillium.

It also allowed me to set the aperture at $f/11$ so that I could maximize sharpness. In addition, I positioned the camera to take advantage of the sun's backlighting, giving the red petals a glow. Experiment with depth of field on your next hike. Photograph the same subject at different distances, keeping your aperture setting and lens focal length constant to see how depth of field changes. Or change focal length, keeping aperture and distance the same.

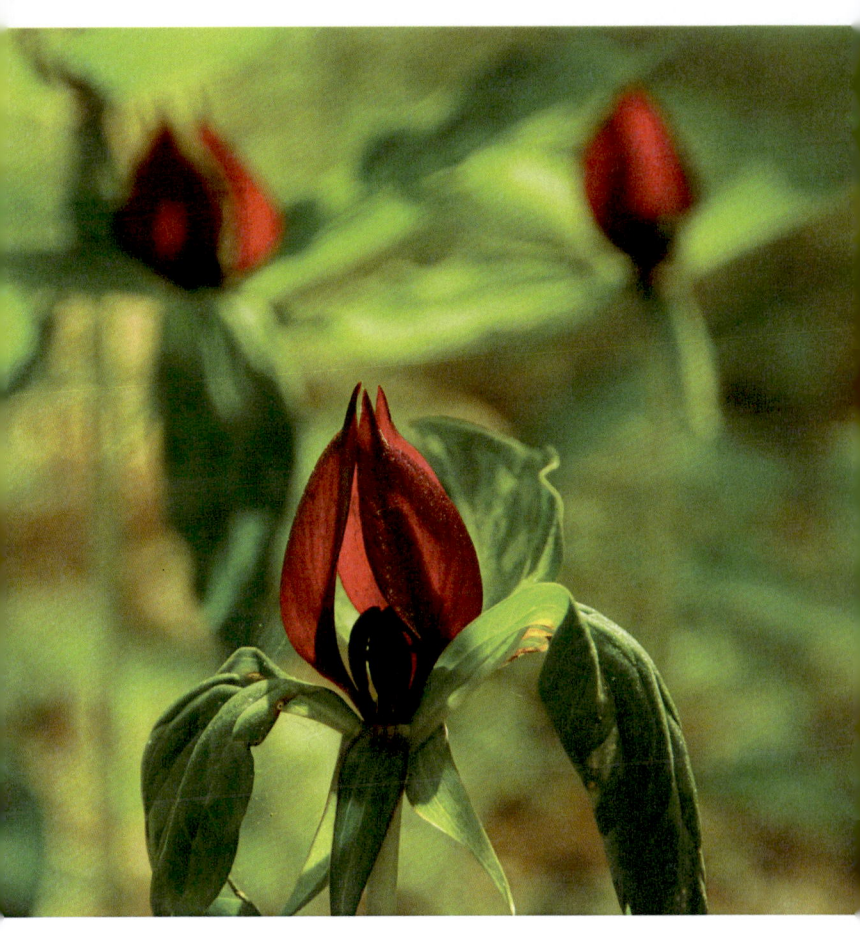

f/11, 1/200 sec, 200 mm

LIGHT
Friend and Foe

Light is both a friend and a foe to the nature photographer. It makes or breaks an image. Its direction, character, and color temperature affect how the subject is illuminated and perceived. Direction refers to frontlighting, sidelighting, and backlighting. Light's character is related to its source. Is it direct sunlight or soft, diffused sunlight (overcast sky)? Light has color, which is influenced by the time of day and meteorological conditions. Early morning and evening light are warmer (with an orange to red color), whereas afternoon light is cool (blue) in color. Finally, light changes, and as it changes, so does the appearance of the subject. What makes this image of Wedge Rock appealing is the lighting and the dusting of snow, which reflects the sunlight. I was fortunate to take this photograph early one foggy morning after a light fall of spring snow. The early morning light was from the back side of Wedge Rock, which brought out the shape and texture of the sandstone. The foggy background diffuses the light, creating a glow that allows the shape of Wedge Rock to stand out. The dusting of snow reflects light, creating shadows and adding to the three-dimensional feel of the

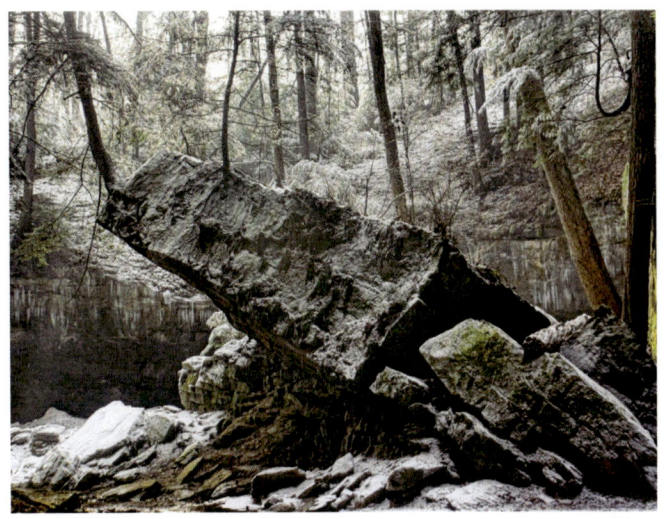

f/11, 1/60 sec, 35 mm

image. To determine the exposure, I metered Wedge Rock (i.e., measured the reflection of light on the sandstone), to ensure that it would be properly exposed and that the background would be slightly overexposed, to give a glow. Because I wanted to bring out as much detail as possible in Wedge Rock, I set the aperture at *f*/11, aiming for sharpness versus depth of field. Explore how light changes nature by photographing the same subject under different lighting conditions. I have spent countless hours over the years just waiting for the lighting to change, a cloud to pass, so that I could get a better photograph.

COMPOSITION
The Rule of Thirds

The rule of thirds is an effective technique for composing nature photographs, and it is the one technique I consistently apply when framing my shots. As you view the scene through the camera, divide the image into thirds both vertically and horizontally. The points where the vertical and horizontal lines intersect represent the sweet spots. It is more pleasing to the eye if your subject touches these sweet spots or lies along one of the vertical or horizontal lines. This moves the subject away from the center of the image, which usually makes it more visually pleasing. To compose this image, I aligned the foregrounded beech trees along the vertical line and aligned the top of the ravine along the horizontal line. This placed the sweet spot on the beech trees and decentered them, making the image more striking. The eye also prefers images with odd-numbered subjects or asymmetrical compositions. For example, I composed the trillium image to contain three of the plants. The rule of thirds is a general guideline, and of course there are always exceptions to the rule. On your next hike, photograph the same subject, placing it along different vertical and horizontal lines and sweet

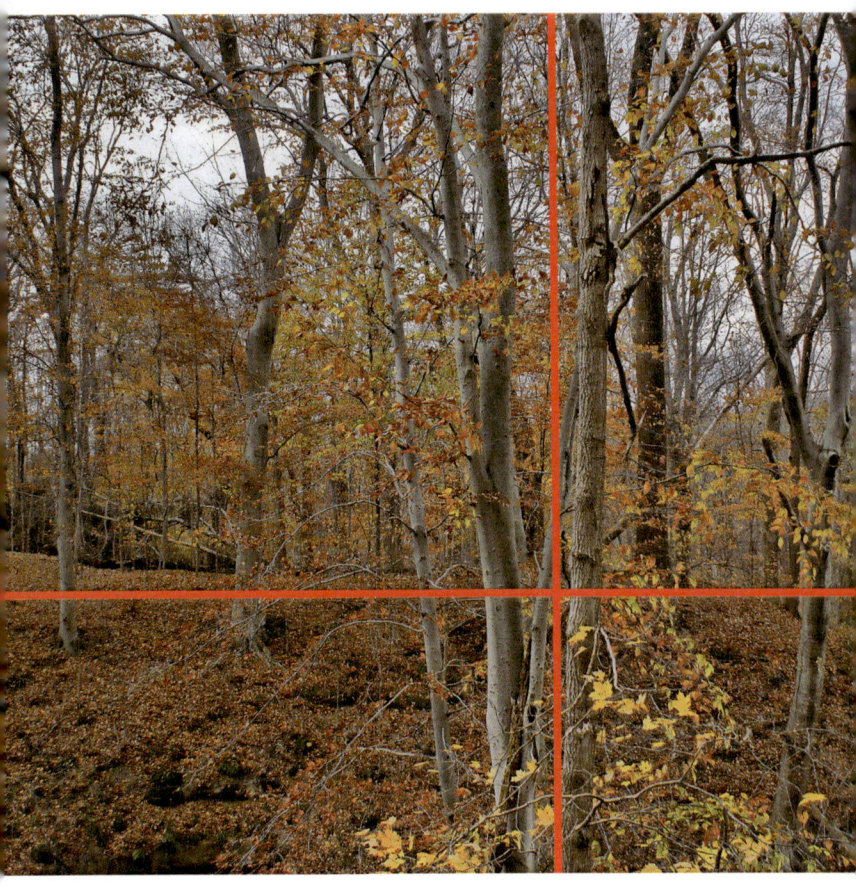

f/11, 1/50 sec, 22 mm

spots in order to see how it affects the image. How does the placement of the horizon along the lower and upper horizontal lines change the look of your image?

COMPOSITION
Line and Shape

A simple composition technique is to use leading lines in nature to guide the viewer's eye through the image. I am always looking for these kinds of lines or shapes in nature as I frame my shots. Next to the rule of thirds, it is the most common technique I use. In general, straight diagonal lines convey action, and curved lines are more relaxing. Curved lines make the eye take longer to travel through the image, giving the sense of a journey. Here, the three groups of lines draw the eye through the image, intersecting in the end and giving closure. You feel as if you are walking through the canyon. It took me some time to find the right camera position to capture the convergence of the curved lines of the sandstone walls and the curved line formed by the creek bed and canyon floor. This required a wide-angle lens (10 mm) in order to place the camera close to the sandstone face and to capture the breadth of the scene, providing depth of field. To ensure depth of field, I used an aperture setting of $f/22$. The combination of focal length and aperture setting ensured that the image would be in focus. In addition to the leading lines, the image is divided into three shapes:

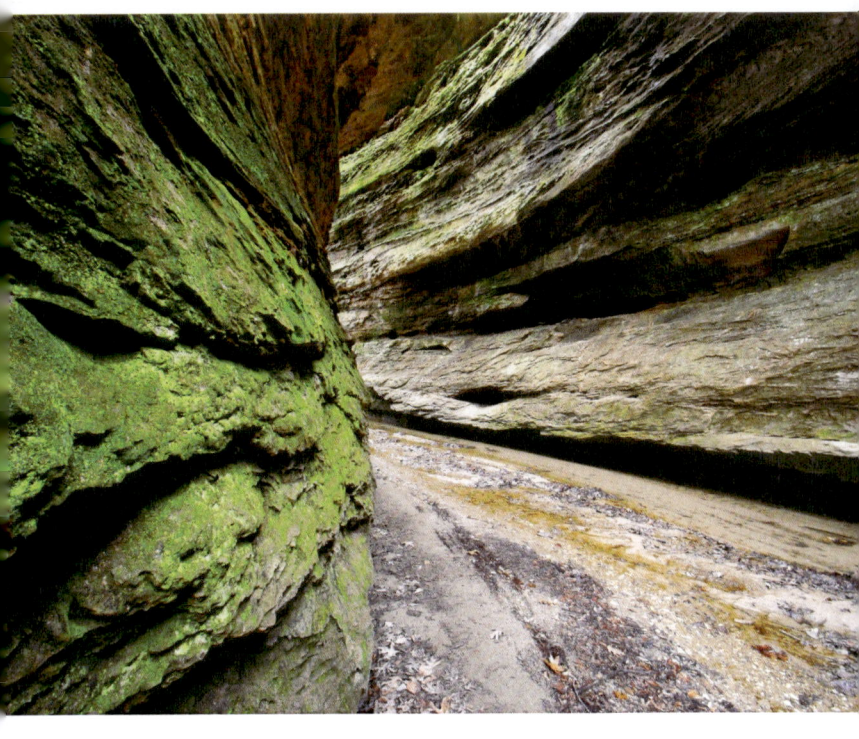

f /22, 13 sec, 10 mm

two shapes created by the canyon walls and one created by the canyon floor; these also merge, bringing closure to the image. As you compose your next nature photograph, look for natural lines and shapes and use these to frame your shot. Then, change your perspective, switching the orientation of the lines and shapes to see how that affects your image, and where they lead the eye.

COMPOSITION
Photostitching

Photostitching is the process of combining multiple images to produce a single, panoramic image. This process has become easy to do with the improvement of photographic software. Although photostitching is commonly used to create landscape panoramas, I also use it to zoom in on natural phenomena to capture more detail. This process increases the size and resolution of the final image. This photograph of ferns growing on a sandstone ledge is a photostitched image: it was made by combining three overlapping images. I wanted to capture the detail of the sandstone ledge and ferns, so I zoomed in on the scene; however, by zooming in I lost the horizontal breadth of the ledge. Thus, I decided to take three zoomed-in images and photostitch them to capture the detail of the scene. I have found that when making a photostitched image, it is best to overlap each image by one-third. I try to find an identifiable marker that I use to guide me in overlapping each image. I have also found that, as you frame the subject, it is beneficial to leave an area around the image for post-production cropping, just in case the images don't align perfectly. It is essential to use a tripod and move parallel to

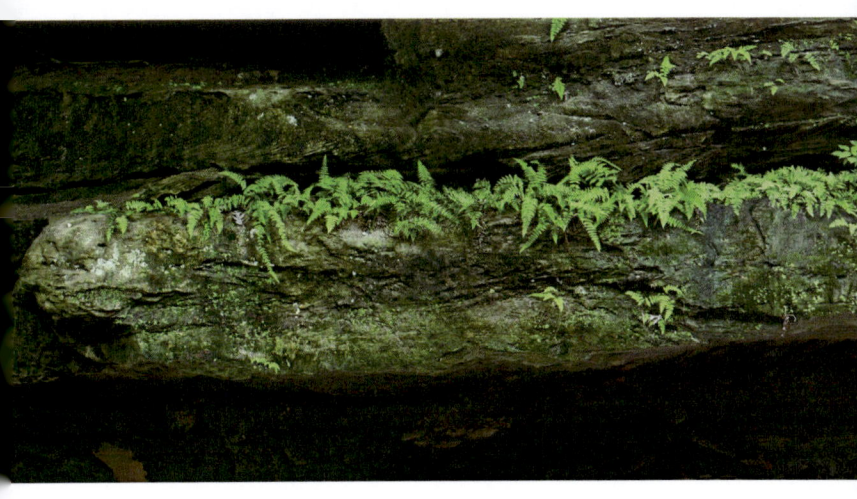

f/20, 4 sec, 40 mm

the subject. It is also critical that you use the same exposure settings and lens focal length. A consistent light source is helpful, and a stable subject is a must—any movement will blur the final image. Longer focal lengths work better as there is less vignetting and distortion, making it easier for the photographic software to stitch the images. Although this image is a horizontal stitch, you can also stitch images vertically. There are a number of photographs in my book, *A Place Called Turkey Run*, that are photostitches. On your next hike, start looking at nature in parts and think about how you can stitch them together to make a whole.

HDR
High-Dynamic Range

Most modern cameras have a high-dynamic range (HDR) setting. This setting allows the nature photographer to compensate for wide ranges in brightness and shadows in the scene. The camera takes three images at different exposures and overlays the correctly exposed image (as set by the photographer) with the bright areas of the underexposed image and the dark areas of the overexposed image, creating one image that compensates for the ranges in brightness and contrast. This creates a photo with rich gradations, as seen here. The HDR setting allowed me to bring out the details and color of the foregrounded leaves without underexposing them. It also underexposed the bright sky, preventing the upper leaves from being washed out (overexposed). Because the shutter is released three times to create one image, a tripod is a must. Any motion in the camera or subject will blur the final image. This is different from bracket shooting in which the camera takes three consecutive images, each at a different exposure: the correctly exposed image, the underexposed image, and the overexposed image. I find the HDR setting to be advantageous when shooting in narrow canyons or in forest environments

f/11, 1/60 sec, 18 mm

where the trees block the sunlight, creating wide ranges in light and shadows on the forest floor. If you have an HDR setting, photograph your subject or scene using HDR and compare it to one taken using a normal shooting mode.

UP CLOSE
Extension Tubes

To get up close and personal with nature I often use extension tubes. Extension tubes are placed between the lens and the camera, which moves the lens away from the sensor, allowing you take close-up shots. Extension tubes usually come in a set of three rings; for example, 12 mm, 20 mm, and 36 mm (the length will vary by brand). They may be used individually or in any combination to obtain the desired magnification. Two things to consider when using extension tubes are depth of field and lighting. As you add extension tubes, you decrease the depth of field and the amount of light that reaches the camera's sensor; thus, you have to open up the aperture or increase the shutter speed in order to properly expose the image. To take this close-up of Virginia bluebells, I used a 20 mm extension and a 300 mm focal length. This allowed me to position the camera close to the flower so that I could capture the detail of the stamens, its yellow anthers and white filaments. A light yellow dusting of pollen is also visible on the blue petal. By getting closer, I was able to eliminate unwanted and distracting details, simplifying the image. A tripod is a must for close-up work, as camera shake will blur the image. If you have extension

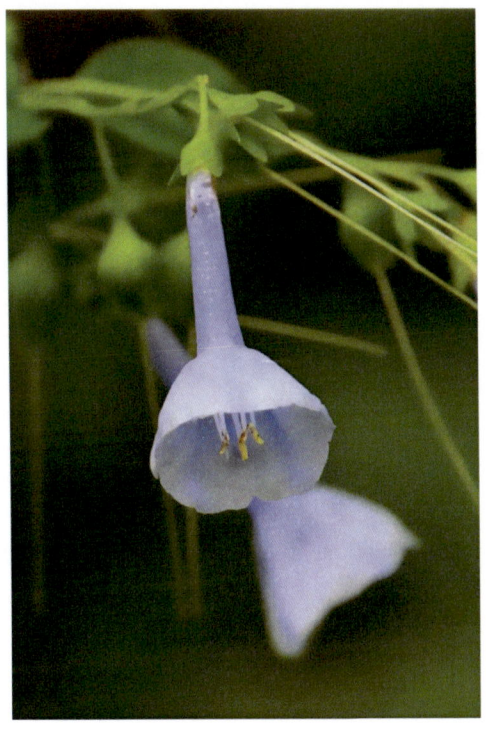

f/10, 1/50 sec, 300 mm

tubes, use them on your next hike to get up close to nature. I have used them to photograph insects on leaves and flowers, buds, mosses, and mushrooms.

FOCAL LENGTH
Wide-Angle versus Telephoto

When deciding which lens to use, there are two questions to ask: (1) do you want magnification? or (2) do you want depth of field? The greater the focal length of the lens, the greater the magnification, which decreases the depth of field and the area captured by the sensor. A telephoto lens compresses space, moving the foreground and background into the same plane; thus, they appear closer together, as in the trillium photograph. Telephoto lenses also have a narrower angle of view, which allows you to crop out distractions. To capture the confined space of the Punch Bowl, I used a wide-angle lens, 22 mm. This allowed me to capture the depth of the canyon, backgrounding the Punch Bowl and foregrounding the icicles. Framing the shot with the canyon walls adds an element of intimacy and draws the eye into the image. Because I wanted a degree of sharpness, I went with an aperture of $f/8$, requiring a shutter speed of 1/60 sec. On your next hike, practice shooting with different focal lengths to see how it impacts the image and changes the composition. I often photograph the same subject using different focal lengths, in the end selecting the image

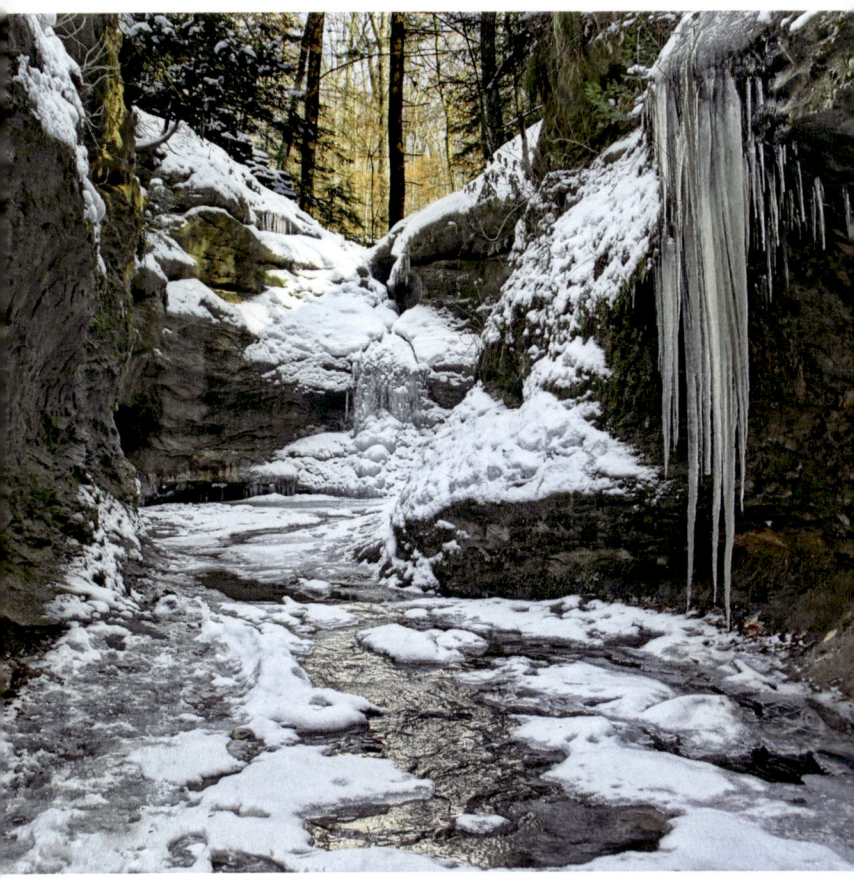

f /8, 1/60 sec, 22 mm

that is more pleasing to the eye. Something to consider is whether or not you want to show your subject in context. If so, use a wide-angle lens. If not, use a telephoto lens.

PLANNING AND LUCK
Taking Advantage of the Situation

Taking good nature photographs goes beyond composing the shot. It involves planning the hike for the purpose of photographing a particular aspect of nature. Although it is about being in the right spot at the right time, there is also a little luck involved, along with the ability to take advantage of the situation. For example, although I planned to photograph Wedge Rock on one of my March hikes, I could not have predicted the spring dusting of snow. I was lucky in that sense, taking advantage of the snow, fog, and light to capture the images of Wedge Rock shown in *A Place Called Turkey Run*. At the same time, I know that if I want to photograph Virginia bluebells, I need to hike the park's floodplains and bottomlands in April. So, in this sense, it is about being in the right spot at the right time. I often plan my hikes with an intent to photograph a particular aspect of nature based on the time and place to take advantage of the quality and direction of the sunlight. This does not mean that I pass up a good shot, though, which is why I always hike with my camera pack. This image of the Punch Bowl illustrates taking advantage of the situation. I had just photographed the Punch Bowl from the

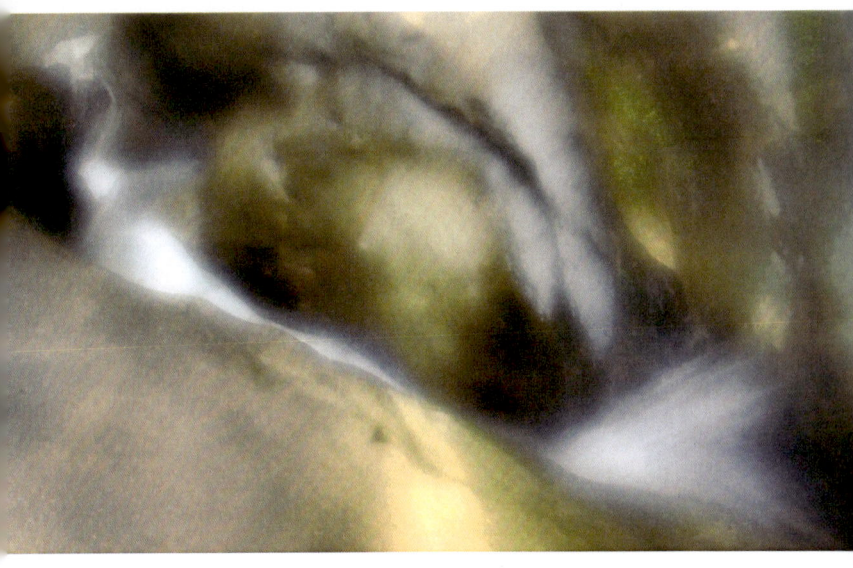

f/11, 1/13 sec, 16 mm

canyon floor and hiked to the rim to photograph the falls from there. Because of the temperature difference from the bottom to the top of the Punch Bowl, my lens fogged over as I removed the lens cap. At first I was going to clean the lens, but then I decided to take advantage of the soft focus and ghostly feel created by the fogged lens. I also shot the image at a relatively slow shutter speed, 1/13 sec, to capture the movement of the water. The wide-angle lens (16 mm) allowed me to include the path of the flowing water from top to bottom. The point is, plan your photo hikes, but remain flexible to take advantage of the situation.

SEEING NATURE
Telling a Story

To me, photographing nature is about being immersed in nature. It is about seeing nature from different perspectives, under different environmental conditions, and over time. It is about telling a story, whether about a place called Turkey Run or a landform such as Wedge Rock. To take these images of Wedge Rock, I took the time to get to know it, to experience it under different lighting conditions and from different perspectives. I always take my time photographing the site, moving around it, photographing it from different locations and angles, under different lighting, and in different weather conditions and seasons over time. On your next photo hike, be sure to take your time photographing nature—spend some time seeing and reading nature and thinking about the shot. The image on the following page was taken from beneath Wedge Rock with a wide-angle lens in March, before the trees leafed out. This allowed the sunlight to penetrate the scene, giving a glow to the background. The image on page 28 was also taken in March, after a dusting of spring snow.

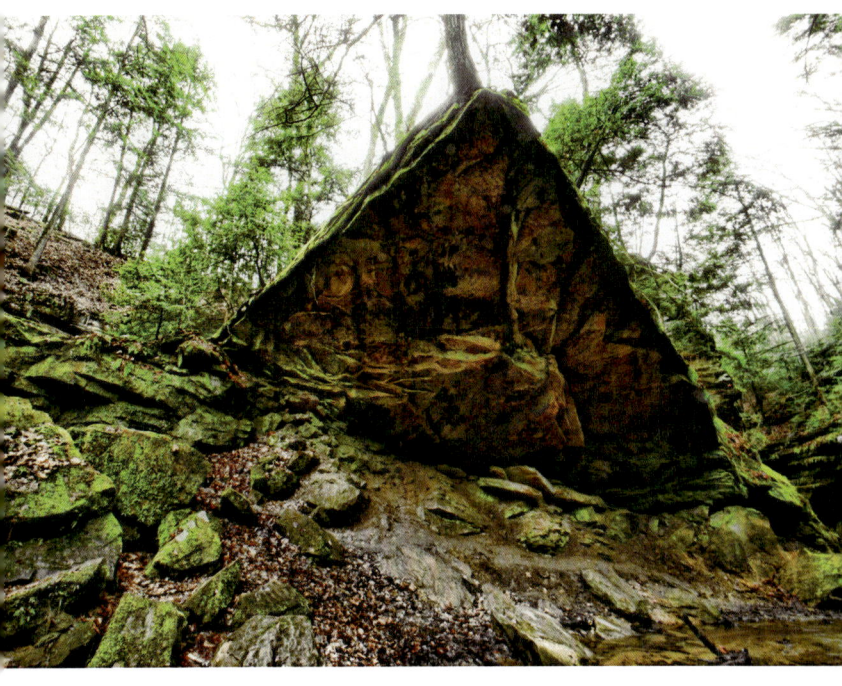

f/22, 3.2 sec, 10 mm

In May, light reflected upwards created an orange glow from the underside of Wedge Rock (image on page 29). The image on page 30 was taken in October just as the leaves turned yellow and started to fall to the ground, contrasting with the green, moss-covered sandstone.

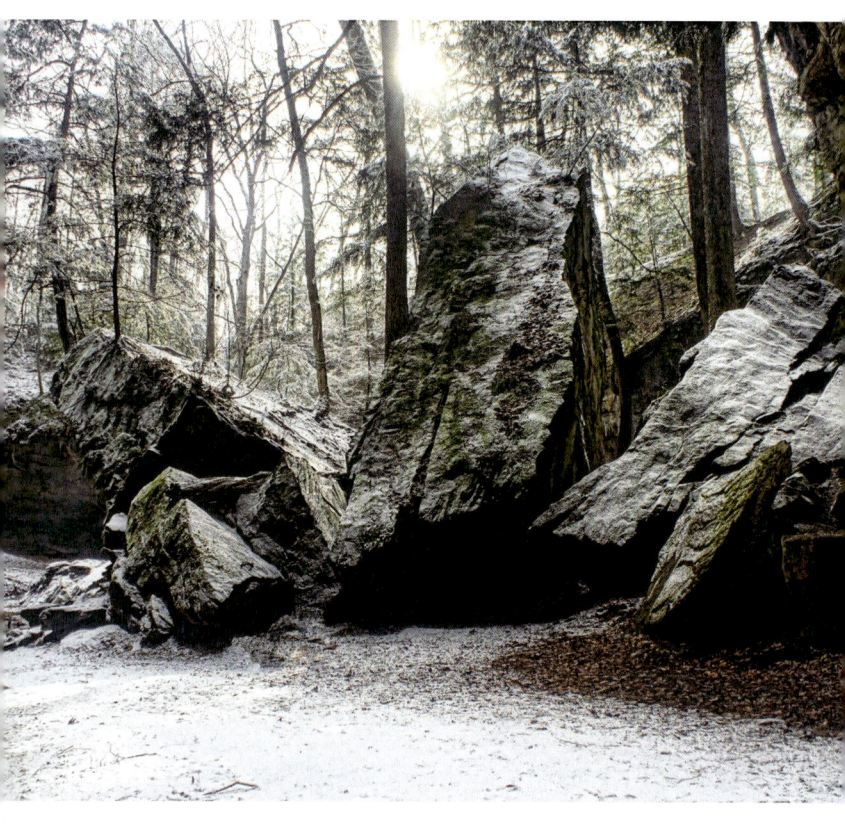

f /11, 1/60 sec, 18 mm

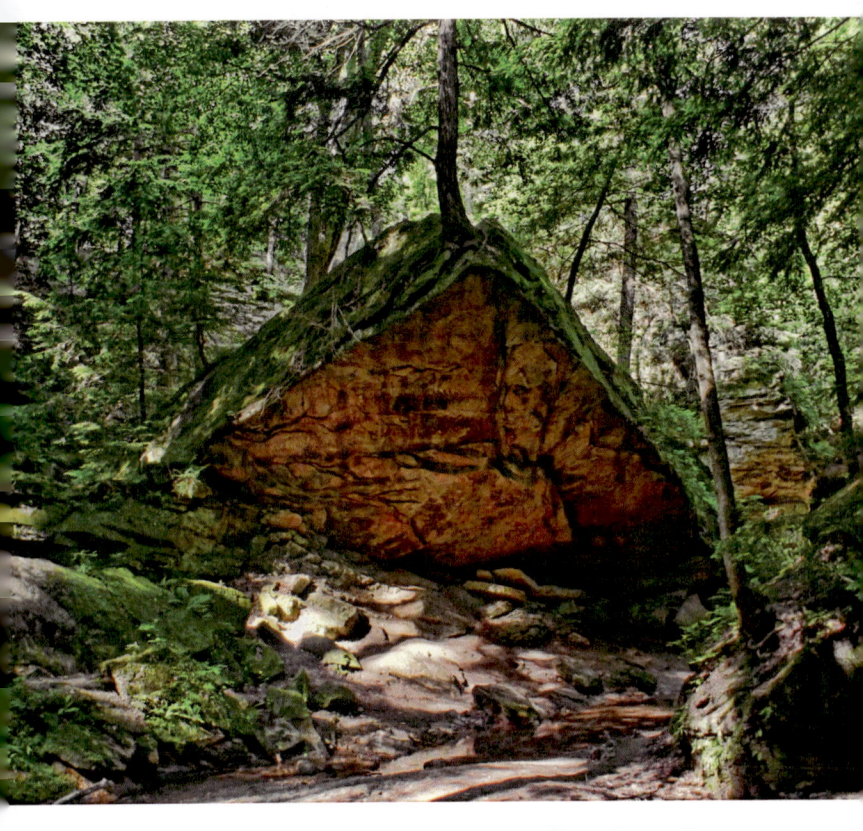

f /11, 1/8 sec, 18 mm

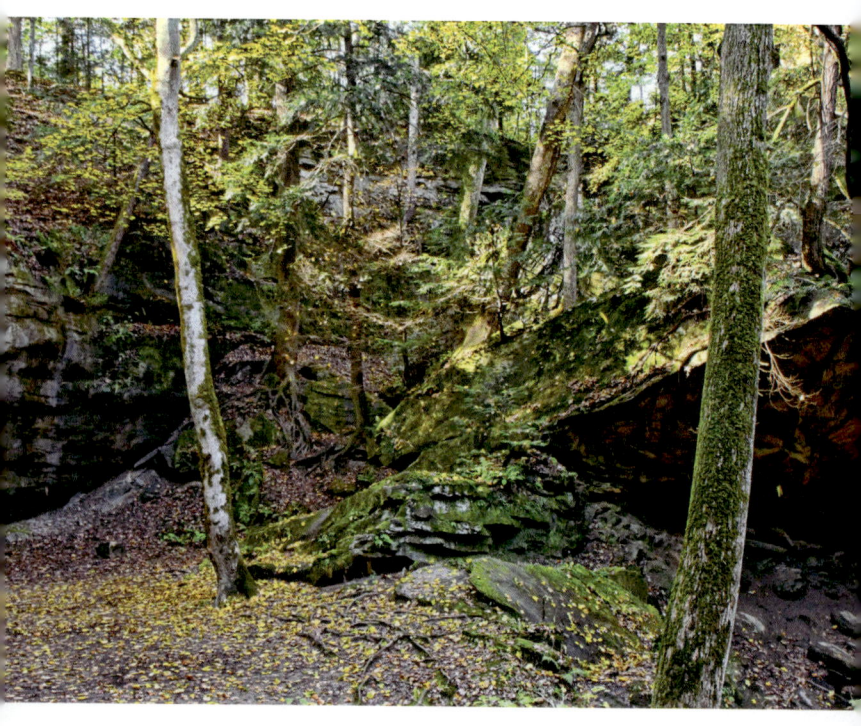

f/11, 1/8 sec, 24 mm

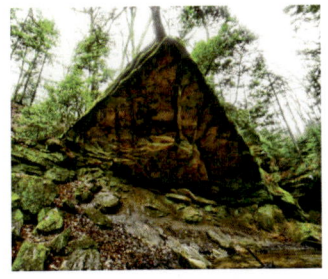

f/22, 3.2 sec, 10 mm

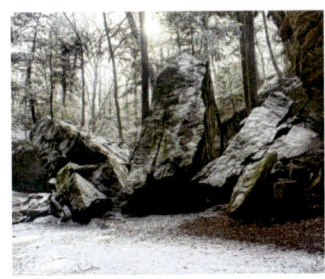

f/11, 1/60 sec, 18 mm

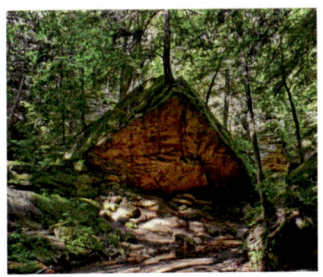

f/11, 1/8 sec, 18 mm

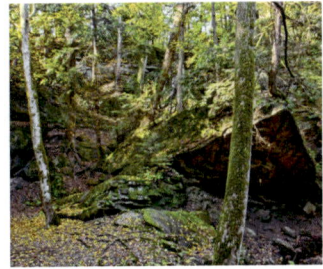

f/11, 1/8 sec, 24 mm

These four images of Wedge Rock provide four different perspectives, variations that work thematically to create a motif. Plan your next photo hike to focus on a theme, to tell a story.

CONCLUSION

The Power and Importance of Nature Photography

My goal as a nature photographer and environmental educator is to use the photographic image to celebrate and honor nature, to help others see, understand, and appreciate the natural world, and to instill in people a desire to preserve and protect our environment. Thus, for me, nature photography is more than taking "good" photographs of nature—it is about using the image to learn about our natural world, to create a natural legacy, and to promote the preservation and protection of our natural world, not only for future generations, but also for the existence of nature in its own right.

Turkey Run and the other state parks and natural areas of Indiana preserve and protect an assortment of amazing landforms and landscapes, beautiful scenery, and abundant and diverse forms of life. By photographing these special places, we preserve our experiences, enrich our memories, and document their natural heritage. The photographs we take and share give meaning to nature, and are visually effective in helping others understand and appreciate the natural world. The power of the photographic image to

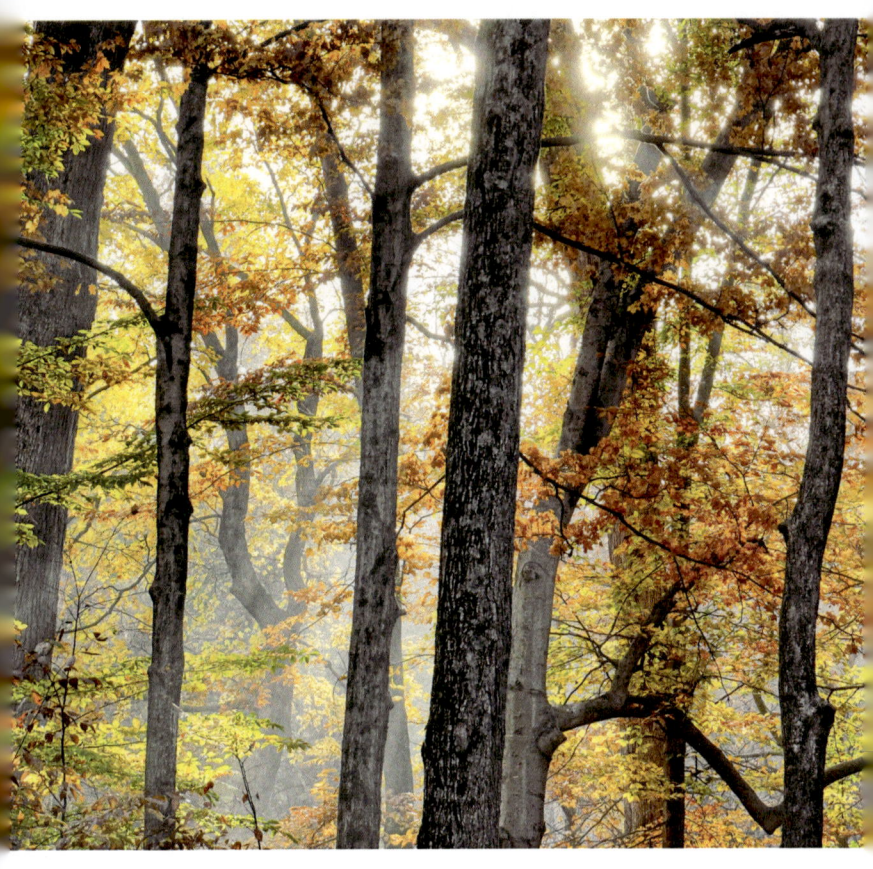

f/11, 1/125 sec, 75 mm

convey a visual perception of nature draws from the inherent appeal and popularity that individuals have toward photographs.

Good photographic images make visible the features, events, scenes, and spaces of our natural world. The images depict landforms, weather events, lighting conditions, and the plants and animals that make up the natural landscape. They capture and display wildlife and plants in their natural settings, highlighting the behaviors of wildlife and the structures of plants, and the spatial arrangement and openness of the landscape. Line, shape, texture, color, and value structure are important elements used in taking photographs that represent nature. Through the use of macro and telephoto lenses, nature can be captured up close or from afar. The camera and lens are tools for developing a sense of place—for understanding our natural surroundings and our place within.

The techniques presented in this book are effective in composing good nature photographs; however, there are always exceptions to the rules, and they are not always foolproof. In addition, there are other techniques not covered in this book, such as framing the subject and fill flash, to name two. And of course, one must practice to master these techniques. I often take "practice" hikes where I challenge myself to use a particular technique or lens to take my photographs. For example, I may only take photographs that involve lines and shapes, or I may only use a wide-angle lens. This forces me not only to

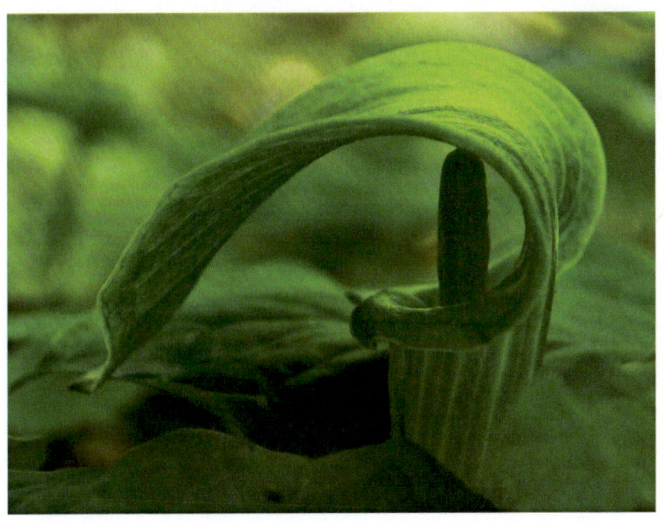

f/11, 1/125 sec, 135 mm

practice, but also to see nature in a different way. Finally, you must also learn to see and work with nature as you compose the image. The more you know about the natural world, the more nature you will see through the lens. Following the techniques described in this book, along with practice, will enable you to take better nature photographs. It will also allow you to better represent and present nature to others, and empower others to appreciate and protect our natural world.